Storm Farmer

Storm Farmer

Collected Poems

Tracey Gass Ranze

AuthorHouse™
1663 Liberty Drive
Bloomington, IN 47403
www.authorhouse.com
Phone: 1-800-839-8640

© *2011 by Tracey Gass Ranze. All rights reserved.*

No part of this book may be reproduced, stored in a retrieval system, or transmitted by any means without the written permission of the author.

First published by AuthorHouse 11/18/2011

ISBN: 978-1-4678-3535-0 (sc)
ISBN: 978-1-4678-3533-6 (hc)
ISBN: 978-1-4678-3534-3 (ebk)

Library of Congress Control Number: 2011960269

Printed in the United States of America

Any people depicted in stock imagery provided by Thinkstock are models, and such images are being used for illustrative purposes only.
Certain stock imagery © Thinkstock.

This book is printed on acid-free paper.

Because of the dynamic nature of the Internet, any web addresses or links contained in this book may have changed since publication and may no longer be valid. The views expressed in this work are solely those of the author and do not necessarily reflect the views of the publisher, and the publisher hereby disclaims any responsibility for them.

Contents

Storm Farmer ... 1
 The Old White Church .. 3
 Two Farms .. 5
 Coffin Wagon ... 6
 Teacher's Note ... 8
 Pammy to Pam .. 9
 Storm Farmer ... 10
 Pittsburgh ... 11
 bridge span .. 12
 river debris ... 14
 Nightgown ... 15
 it's a herd of turtles ... 16
 go dutch ... 17
 Meeting Halley .. 18
 home sprouts ... 20
 blue island .. 22
 this mess is a place ... 23
 Sleeping In Sky .. 24
 folk lure .. 25
 Yearbook .. 26
 jensen's ledge .. 28

Butterfly Wings .. 31
 waiting .. 33
 October .. 34
 Butterfly Wings ... 35
 Harrisburg ... 37
 Satin Stillness .. 38

room empty,the leaving ... 39
the heavy ... 40
loneliness ... 41
paper dolls ... 42
punctuality. in actuality, ... 43
intersection ... 45
purple asters are in bloom .. 46

September Mourning ... 49
Election 2000 . . . the Magicians ... 51
tender november layers .. 52
September Mourning Tripod .. 54
pieces of a thousand years ... 57
nourishment .. 58
Allow a Slice of Sonnet from My Heart 59
Window Panes .. 60
Ballad of Andy Brown ... 63
Like Alice, .. 64
Black Armband ... 65
Fighting for Peace is like Raping for Love 66
the tribe inside .. 68
piped the People of We, ... 69
A Litany of Lies a Listing .. 70
barbeque at Powell Library .. 73
to the fracking gas frackers: ... 74
hosting the 21st century, .. 75
bumpers .. 77
radioactive rain ... 78

Crows Into Night ... 79
i see ... 81
Neighbors' Talk .. 82
Tangerine Gates in Central Park .. 83

 the brown bird..85
 the drink ..86
 oh brother, ...88
 glass breaks, fire is slow ...89
 when wearing this bonnet, excise chatter...................90
 where is summer? ...91
 Blue Jean Sonnet ...92
 beast..93
 grace zone ..94
 Crows Into Night ..95
 wingless...96
 hands in march ...97
 white paper bag..98
 Bone..99
 riding,..100
 ocean song ...101
 gray whisker shadow ...102
 autumn cracks ...103
 look up ..104
 the daughters and the locust root..............................105

Water Bearer..**107**
 women drumming..109
 sweat lodge ...110
 Woodstock Nation...112
 Rainbow Gift..113
 strawberry moon ..114
 walking earth...115
 celebrate life..116
 the golden eagle, ..117
 watching dreams ..119
 dear vincent,..120
 Water Bearer..121

Mountain Home ... **125**
 Cushetunk Falls .. 127
 river glass ... 128
 feathers full of music ... 129
 supper table ... 130
 Mountain Home ... 131
 early .. 132
 sunrise sand ... 133
 eagle speak ... 134
 the hot lazy .. 135
 green heron hunt ... 136
 inside hemlocks walking .. 138
 ice-storm taps .. 139
 Ice Flight .. 140
 evening drapes .. 141

Storm Farmer is Dedicated to All My Loving Family . . .

my parents, Pat and Dale Gass, who sang lullabies, recited nursery rhymes and read poetry to me when I first arrived on the farm.

my husband, Mike, who has supported my writing for over three decades, with wise critique and much patience as he listens to every revision.

my sons, Cole, Leif, Sage and Skye, who stir the deepest love and creative experience and have graciously made room for all my poetry work.

my community of friends, who enrich my life with experiences of good company, food, play and an interest in peace for earth and all her humans.

A Sincere Thank You to:

Mary Greene, founder, and the Upper Delaware Writers Collective for all their in-depth support,

Sandy Conway for editing, and Will Conway for preparing a delicious dinner,

and especially
Cole Ranze for the cover design.

Storm Farmer

The Old White Church

1. Overlooking a crossroad of traffic and lives
 an old church once perched on a hill
 big and boxy with the clapboard painted white
 standing closer to heaven

 an old church once perched on a hill
 like a ship anchored in a sea of gravestones
 standing closer to heaven
 keeping watch over ancestral bones

 like a ship anchored in a sea of gravestones
 full of dark wood with cracked varnish
 keeping watch over ancestral bones
 channeling chanted prayers from creaking pews

 full of dark wood with cracked varnish
 smelling the years through musty old hymnals
 channeling chanted prayers from creaking pews
 I remember swinging on the bell rope

 smelling the years through musty old hymnals
 and the hard tug of the ragged cow-tail rope.
 I remember swinging on the bell rope
 under the rhythm of a single clanging bell

 and the hard tug of the ragged cow-tail rope
 I added my own voice to that ringing
 under the rhythm of a single clanging bell
 and sang in the choir on risers at the front of the church

 I added my own voice to that ringing
 getting still higher from the singing
 and sang in the choir on risers at the front of the church
 to sun streaming through green and amber glass.

2. When I was ten years old
 crowds of new people came
 and we moved to the new red brick church
 and the old white church kept watch

 as crowds of new people came
 their children played in that old sanctuary
 and the old white church kept watch
 for more than thirty years

 their children played in that old sanctuary
 it stood a hollow icon of the community
 then thirty years later
 this old church was razed asunder

 as it stood a hollow icon of the community
 they tore the old white church down
 this old church was razed asunder
 it became the next grave in the ground.

3. Where is the old white church perched on its hill
 standing closer to heaven?
 In the rush of moving people a time is being forgotten
 a time when people walked slowly and to a church

 standing closer to heaven
 overlooking a crossroad of traffic and lives
 I remember a time when I walked slowly and to a church
 that was big and boxy with the clapboard painted white.

Two Farms

Childhood stays on the farm, feel a lifetime ago
but what I remember most is the sultry scent
of each season's weather and hard pouring sweat
gasoline fumes trailing from tractor exhaust
oozy axle grease wiped on coveralls
fresh green hay packed in the barn
next to bins of nutty smelling grains
and cow manure reeking from under Pappy's farm boots

which he kept on the top step of the cellar stairs
just on the other side of the kitchen door
where Grandma worked to keep the cookie jar full
penetrating the entire room with
the fragrance of homemade ginger snaps.

I remember the aroma of warm cinnamon in sugar
steaming from apple dumplings baking for our dinner
or the thick smoky smell of fried chicken
greasing my nostrils before supper.

And Grandma cheerfully whistled tunes standing
at the kitchen sink, peering out the open window
where the breeze entered, carrying the thick sweetness
of purple petunias wafting from flower beds below
there she would watch the hummingbirds come
to work the trumpet vine dripping from the trellis.

All these memories make me feel content
on my own little remnant of a farm where the barn
belongs to a separate parcel of land.

Though I only grow sons and flowers
there is still plenty of hard summer sweat
and in my kitchen a pumpkin pie sends ginger
and clove floating through the warm air.

Coffin Wagon

There was little left of November, but the crisp sun
between naked timbers, their grayness a contrast
to the blood-red paint of the Radio Flyer
my sister and cousins, *the boys,* riding it two or three
astride, bumping downhill over cobble-stone roadsides.

Today, we make runs to Grandma Gass' house
even on this sudden-death school holiday
making sharp turns with *Radio Red,* we hear our glee
trumpet too brightly, but we are children, easily slipping
from sadness, wagon play replacing the shape of our grief.

We talk off and on about President Kennedy
how we watched his murder replay a stone's throw away
from our eyes, blood and brains in shades of gray
and my surprise, to weep when Walter Cronkite cried

and how we had just seen President Kennedy alive
last fall, riding in a long black car past our backyard
past the guardrail where we sat a few feet away
his smiling eyes looking right at me as he waved.

Today we try on large words like assassinate
and talk about how Caroline's dad is gone
and she's the same age as Jimmy and me
his death repeating on black and white TV.

Still, we find the old khaki-green army blankets
that belong to our Grand pap, dads and three wars
all scratchy, woolen and smelling of damp cellar
and drape the Radio Flyer like an amusement ride

a great green swamp scum or a monster's olive eye-lid
we harbor in the dank midnight deep in the wagon-bed
where by turns we lay to receive the wildness of jerking
pulls and spins, steered by a length of cold black metal

as squeals and laughter gobble up the dark air
under the hooded Radio Flyer, we feel more alive
whirling inside a caterpillar's cocoon or a Gemini rocket
or a horse-drawn coffin wagon, in a funeral procession
clip-clopping through the center of our entire world.

Teacher's Note

It was Mrs. Kennedy
in the third grade
she took the time
to write the note
 in the third grade
 on a yellow page with blue lines
 to write the note
 where a child's first scrawl
on a yellow page with blue lines
a couplet about buttercups
where a child's first scrawl
came dancing out
 a couplet about buttercups
 in perfect rhythm and rhyme
 came dancing out
 from somewhere inside
in perfect rhythm and rhyme
a tiny poem emerged
from somewhere inside
and was sent home with praise
 a tiny poem emerged
 and like a thirsty seed watered
 was sent home with praise
 to note the poet in the child
like a thirsty seed watered
she took the time
to note the poet in the child
it was Mrs. Kennedy.

Pammy to Pam

Before this day she could sit on her hair
two long braids tucked under her derriere

but she is twelve and going to a wedding
in the afternoon, in hot June, in the hot 1960s

and junior high is just two months away.
So this morning, she marks being a woman

with a haircut, a little tease and hair spray
and the *girl* in her is severed like a pair of braids.

Like custom made, she wears a hand-sewn dress
a faux flower centered between her budding breast . . .

> There is this time when a girl is half a woman
> between trees to climb and mixers with charades
>
> when her mother still sews the dress she wears
> then finds a small paper box to tuck away
>
> the *girl* in her daughter, save her forever
> wrapped in a coil of fresh cut braids.

Storm Farmer

In July, when scarlet blossoms of Bergamot overlap
Echinacea's honey tipped cone, when heat like the tropics
is upon me, upon my wet beaded brow, and I say, *It'll be
rain tomorrow*, palm swiping sweat, *not salty,*

just a wash of strong poetry. I smile
knowing the chair will be waiting to hold me
to watch walls of water flood from holes in gutters
that chew away at the porch edge, like fringe on a torn hem.

I will stay seated when wind
picks up and pushes me hard and reckless
when lightning leads its sharp strobes too close
leaving thunder ripping duets with my thumping heart.

I'm not moving, I'll think. *Going to sit tight.*
Storm will plant its strong discourse, press its wildness
against my fear as I hear hardwoods crack, thunder rumble
toward me like a freight train approaching fast.

It is then I'll lean into the clouds as they wring out my heat
and welcome me, the storm farmer to the south porch
pen and paper, my pitchfork and mow
there will be a harvest to get in.

Pittsburgh

walking by rivers meant
padding along sidewalks or city streets
one stacked upon another
no sign of a blade of grass or leaf

and at the point where the peninsula
of land bears the fork of two rivers
 the murky Monongahela
 and the emerald Allegheny

their colors flag
into a brown and green field
waters that birth the river Ohio
a two-toned striped flow

there, right there, I could reach
into the first moments of merging waters
the infant Ohio
full grown and wide as both parents.

bridge span

pennsylvania rivers seem to flow
next to and through my lifespan
the wide and deep ohio began

near the place i got my start
running full of barges and tugboats
hauling coal for pittsburgh steel
 slow mournful fog-horn-ers
 drifting to hilltop houses sighing
 lullaby sifting past open window screens
 nightly warnings to my approaching dreams

and crossing ohio river from bank to bank arching
paved paths joined to suspension bridge trusses
 adorned with turrets at their peaks
 made by the union-man

steel factories loom along the river
oversized boxes of black metal
erect smoke stacks old cigar puffers

three shifts dumping rail cars
 of blaze orange slag slow pouring
 hot lava lumbering down doomed river bank
 like molten icing dripping lighting up the sky
 awesome fire like on fourth of july

at river s edge steel mills puke murky waste from
sluice pipes suffocate fresh mountain flows

for me three decades cross my life spans to now
and a river runs next to me again

the upper delaware with pantaloon lace
of sweeping hemlock and fir where bald eagle
perches a brooch on a bodice of green

and this river rushes protected and well
teeming with fish fresh water mussels and eels
and people wading and swimming in her swells

under a bridge spanning to new york s
catskill mountain foothills it sports a victorian plaque
framed by a budding cast iron vine that reads
1901 Built by
American Bridge Company

flooding memories back to those ohio river bridge builders
five miles down stream from my hometown

and now standing on its wooden deck this bridge
 adorned with steel lattice rickrack
 and cast daisy rivet covers
connects my life spanning east to west
a one lane crossing in near wilderness and provides
safe passage for reminiscence of my earlier sooty decades

river debris

the Ohio River regurgitated the trinket
spit it out of its sandy lower jaw
a fish-bone dislodged from muddy teeth

Granpap Gass spied the glint from the cab
of a crane lifting steel pipes and there
he dug up a horseshoe shaped rhinestone pin
out of the gate for the next leg of its race

long before we tried to guess how it landed there
 did it snag off, flood-swept, a broken
 heart's torn toss, full of regret
 33 sparkling rocks rolling in the wet

once rinsed and brushed clean, the pin took its place
jabbed in the wall next to the four-party phone, to wait
for a dozen years, until the party-line rang just two

and a jeweler was secured to announce the news
of diamonds in European score, old glitter split
rough cuts, stable as this family's found treasure

the diamonds equally divide to Granpap's three sons
the oldest one, fashioned a ring for his wife, now gone
the diamonds pass on to three daughters, of whom I am one

now driving home to Moon, Pa., to collect my ring of gold filigree
and 3 precious stones, heirlooms, mommy-gem-memories,
all ways to see it, but I have fun calling this glinty gift
from the garbage-gods, my recycled Ohio River debris.

Nightgown

My mother-made
fuzzy flannel nightgown
spent many winters warming
tucked sleepy feet
in icy cotton winter sheets.

Gown grown old
with curled yellowing eyelet lace
mends on faded flower face
worn to torn cozy friend
now helps me dust my bookends.

it's a herd of turtles

where i walk barefoot, outside
on our bluestone rock walkway
courting the january single digits
i'm wearing pajama bottoms south
of three sweaters and north of ten toes
and follow my dog, bingo, stone after stone
dry and clear between bumpers of snow
around the bend under the lilac's silent winter buds

 half the snow melted last week and
 today i can finally collect the sugar maple leaves
 that stick damply together like a great brown batter
 in the middle of a crystal cookie sheet
 under broad gray branches, quiet for a tree

i stand watching the iceberg sky
until my feet burn from beneath
from the smooth searing arctic plate
dug out of the earth on our property
chiseled apart then puzzled together

 a parade of snapping turtles napping
 and i turn and track over the shells
 their broad backs content to wait in line

i notice how each rock feels under my feet
smooth, curved, rippled, rough
always solid, unyielding bluestone
a safe trail to our kitchen door

gooda morn,
a cup of tea?

go dutch

it's easy as pie to share a recipe i know by heart
and i'll tell you now i double or triple it right from the start
because there is seldom just tea for two
at our table in the kitchen, my home's heart

this is my family's favorite, it's creamy, even silky
a dark chocolate treat from my mother's recipe
but with one small tweak; i call it dutch cocoa pudding
i promise, it keeps in the fridge, but won't last a week

to keep track of the ingredients, remember just six;
three wet, three dry and plan everything to mix
in one large handled pot because
this recipe is cooked on stove top

first, stir the powders of sugar (half cup)
cocoa powder (one-third cup), make sure the cocoa is dutch
then corn starch (two tablespoons)
try to find the non-gmo type, the rumford brand is good
add to all this (two cups) raw cow's milk

and using a wooden spoon and medium heat
stir until the powders have disappeared in a wet beat
then add the last two ingredients, as a matter of fact
by first blending in a bowl, (two) egg yolks and vanilla extract
(two teaspoons to be exact) and pouring the yolks
into the milky mix and be sure to remember
the perfect pudding trick is to constantly stir
stir, stir, stir about twenty minutes or more
until it's boiling and thick, then you pour into
a bowl and let it sit a short while before you finish

cooling it in the freezy-fridge for a couple of hours
then dish it up to delighted family and guests (a happy audience
is the best) a most delectable dutch cocoa pudding adored
so easy peasy, lemon squeezy, for such a tasty score.

Meeting Halley

Four of us climb
breath blowing clouds
into a crisp night air.

Cole sways along, perched
in his baby backpack
under a sparkling star-scape

we track through fields
where the hay is long enough
to wear coats of frosted dew
and tangle the toes of shoes

up to the top of the mountain
we hike to meet the sky
and Halley's Comet

searching south, our friend
Steve points out a misty
conical haze chasing two stars

all we can whisper is, *Aah!*
to a small wonder of soft light
dancing in our eyes like a jewel
pinned to a polka dot sky

there she is
space dust speeding
quivering in the night's pitch
queen of the comets passing by.

Celebrating, we pour
red wine into paper cups
make a toast to warming up
eat bread with cheese and

digest the thrill of seeing
this venerable comet
circling Earth again.

We each share stories
that our grandparents told
and guess how Halley
might have looked to them

then laugh at the thought
of her next visit
as we imagine
baby Cole an old man.

home sprouts

we bow to pray
because we first knelt
to smell the flowers

and we all give birth
from petals to baby hands
dew-damp, son-shine heads

our four-boy family
suckling babies at my breast
husband, you stand back.

i grow soft-plantings
from you, their gentle-father
in this together

each breath is a prayer
its rhythm found in son-beams
shiny children-kind

laugh, play, love, bright eyed
green leaf, white water, blue sky
fresh people in nest

different. the same.
humankind, big buddha brains
flesh, bones, consciousness

magic-carpet ride
a peace of place, home;
coal fire in the parlor stove

fresh sage drying nearby
or wading in our strong river
or in an old hemlock forest

we call home
now, half our hearts live
across two worlds

and i have a daughter-out-law
in shanghai, china
now, besides skype

we have love
and that takes no time getting there
love gets instant reception.

blue island

i'm at sea in the laundry
clean stacks of folded clothes
resemble a city skyline
on an island that is the blue couch

i'm adrift in the dishes
collecting scattered cups and bowls
those poorly placed home decorations
flotsam in the living room
under a chair, a particular spoon

reeling off course delegating chores
competing with video schemes
loud hip hop that won't stop
my kids mesmerized by e-screens

i navigate past toys sprinkled on floors
where hair-balls tangle in corners
with day-old apple cores
past tables holding the daily catch

and wet towels tossed over doors
disoriented in the rising flood of chaos
and crashing currents of everyone's roar
this ship called *mother* has just run ashore.

this mess is a place

my home is full
of busy young men
and Snow White
has not yet found us

in the woods on a mountain
above the river valley
but she is welcome
as my princess in silkish armor

to come and keep my place
this peeling clapboard farmhouse
these thirty-eight dust-dull windows
where tiny spiders string their lives

there, looking out, i have been known
to wonder, *where is my wife?*

Sleeping In Sky

Late morning! squeak the creaky stairs under foot
but the woody music fails to stir you.

I peek into the room, that you helped paint sky blue
adding white clouds with crumpled paper towels

your slumbered breath lifts your back in measured caress.
Mildly surprised by the reach of your body along the sheets

I quell the instinct to nuzzle next to you, and instead
I slip silently from your blue-sky room

to pen this morning story; that when you were almost
twelve you loved sleeping in until almost noon.

folk lure

friends arrive
 snow meets
 mudroom floor

candles fired
 olden heat
 burning core

table attired
 potluck greets
 hungry hordes

children drive
 sleds fleet
 on crystal tor

winter desires
 guests replete
 once more

Yearbook

2002 Cole Micah

Door
Fleet the days wander
our young man
turns to cross the threshold
a passage
to a world that waits
his wonder.

2005 Leif Adler

Flight
Fly out of our nest
your wings are strong.
Soar into your life
through the world
beyond.

The sunshine is smiling
in your eyes, like two
moons.
Sweet gentle Leif,
at a crossroads in June.

2009 Sage River

Steps
Your first were taken
as a 10-month-old sprout
chasing brothers
in red rubber boots
when you stepped out
golden mane waving
in your wake
flying through each year

until you arrive here
at the step you take
somewhere beyond home
the step you'll pack
your cursive grin in
the step you'll spend
your kindness on
this step that calls
"Sage River" before tossing
you into pulsing currents
that quicken into life.

2012 Skye Forest

Caboose
Our little Skye-guy
and last born, fourth
brother on the loose
leaping on puppy piles
kicking soccer balls
in rhythm with your guitar
you grow like your smiles

and now, on your way
out of our shelter
where you stand today
at the top of this mountain
scan the horizon
between sky and forest
listen to birds in chorus
caboose to engine
a grown man before us.

(and no more school bus!)

jensen's ledge

in her dream she flies from a ledge
over the delaware's dark green waters
below the quarry's edge
the ox bow's center
drifting over the sweeping curve
of dark hemlock currents
her unguiculate feet reach down
and she catches a glimpse in the moving mirror

 my river story tells of giant bluestone boulders
 wading waist deep in dragging currents
 slip sliding on sunken slippery rock
 splish spliding and spilling like a fish
 and at skinner's falls in warm weather
 bring Rocky's pizza thursday to the river

 my sacred story tells of sweating in earthen wombs
 a lodge built of saplings and woven rugs
 searing rocks and steaming heat presses
 streams of sweat trace down my naked body
 crawling around ceremony and hissing rocks
 around song and poetry undressed in the dark

in her reverie, arms flutter with plumes of muslin strips
like swan feathers gracing a fairy queen
framing her own specks of poetry
freckled on white cotton wings
lexis undulates in her lucid dream

 my birthing story tells of four baby sons
 born to nest and nurse pure sustenance
 as tiny chubby fingers open and squeeze
 kneading soft skin of breast, at last
 coming to rest with the weight of sleep
 tucked safe and sound in our family bed

 my pot-luck story tells of crowds in kitchens
 loading the table with homemade dishes
 all my relations and soul-food cooking
 grains and beans and greens and wishes
 serving drumbeats for dessert around fires that listen
 then sledding or swimming under starlight kisses

in the dream she soars on ragged wings
circling upstream with a bird's eye
review of her life stitched from illusions
but she could see neither
the beginning nor the conclusion

 like the train occupying the tracks
 on the crook beneath the ledge
 there is no engine or caboose
 as each coil around opposite ends of rail
 hooked round mountain bends

 my walking story tells a tale of a violet velvet scarf
 flowing and following behind my hair
 wrapped in whipping winter weather
 away and along the sweet running delaware
 a soaring eagle pierces my attention
 leads me back to green mountain

 my bluestone story tells of jensen's ledge
 hiking a mile to the rise and kissing refreshment
 a stream satisfies my thirsty lips and falls
 hundreds of feet to the river's sweep
 swinging my legs over the edge of smooth rock

 i imagine how birds feel flying

in her dream she journeys weightless
musing plumes encircle her head
a halo enthusing the stories to shimmer
from the center of her tilted feather crown

and she imagines how birds feel flying

Butterfly Wings

waiting

a deer lay
one shoulder
on the road
head tucked
into neck
eyes slumbered
four legs folded
poised to sleep
with calm
acceptance of
dark night
on hard road
white line
and headlights

streak of blood
on gravel
beyond her tail
red exhaust reveals
absolute sleep
when death arrived
doe was waiting.

October

I watch death come
withering, shaking
riding on home

I see death's destruction
the toll it takes
on everyone

the seeping wound
the sunken bones
there is no comfort alone

but my search goes on
through tear-flows
and moans that are my own

for not being able
to ease death's pain
lingering as it conquers

grotesque, corroded flesh
I heave at death
shake and quiver

at its coldness
leaving a paper shell
with barely breath to speak

I cannot explain my hunger
to be held, caressed
the release.

Butterfly Wings

for Patricia Ruth Hartenbach Gass

My loving mother, house cleaner, family feeder,
bedtime reader, children scolder, virgin record keeper
left me without a trace, vanished like a fainting maiden
fallen on her back, lying still in a cement vault
in a shiny coffin saturated in body water
pores seeping like a sieve holding back a mighty ocean
large and gray, full of life and rotting decay
waves dancing with the wind, onward they sail to begin again.

And my mother rose like smoke and planted a kiss
from which I awoke, strong and wondering.
She flew on wings of angels, through a cloud of sin
to erase the drink on my breath and chase the demon hovering
clinging to my back, scrubbed it away and poured it out
into the bushes and down the ditch by the side of the road
outside my bed where I awoke, startled and sleepless and wondering
what angel has entered me?

And the phone rings plenty of sorrow, and in the hour
I know that it was mother who died just then
dropped off and out of her body and journeyed east
to find me in a top bunk on the third floor
with two people sharing the bed below, like want and need.
All this, plants a seed that begins to grow an abundance of change
and I spend my days finding the tools in the shed, that voice
in my head, to harvest my understanding of the other side
where her kiss slid through hard barriers of the heart
and mind and beliefs of old times.

And her journey blends into mine
and I know where we began together this time
when my soul slipped in the same invisible door
that she just slipped out
that crack of dawn, that magic of dusk
to wait for my body to be born
that instant and endless time, our never ending story
my nine month wait when I lived in and around her
my nest of warm light and love
water gathering inside a balloon of blood.

And there I was inside, unknown, invisible and in a state
of grace, and mother knew I was real and believed
sight unseen, and my fingers fluttered like butterfly wings
stirring her sweet waters that were my breath
when I first said hello.

And I know by faith that her lips whispered
the mystery of love when she entered
deep into my center, into the earth
through my red roots and my forgiving womb
the moment she died, when she last said goodbye.

And my mother is sure footed on her way
leaving me touched and in a holy place
sending me down my own path with her last kiss
invisibly fluttering against my face
blowing her last quiet breath and floating on to grace.

Harrisburg

I sit eating
a twenty-five cent bagel
with no butter

in a park
with no benches

forget-me-knots crouch
in the unthawed sod
and surely are to be forgotten

like death
I'm halfway home to see

like bus rides
and airplane flies
and death
I'm going home to meet.

Satin Stillness

Mother beauty surrounded by satin
so still is her encounter with death
where youth leaps out from sleep.

It's shocking to touch her face, hard
transformed to a sculpture of cold clay
her lips feel like smooth winter pebbles
and indicate the shyest of smiles.

Such elegance embraced by satin
the sweep of her lashes frozen in death
her hand gracefully overlapping the other
as if caressing her satin cover.

room empty, the leaving

is all that's left
the lifetime lived
the quilt frame erected
and dismantled
the mattress starts off firm
then succumbs to lumps

the babies start off pliable
then sharpen to teens
who prick or prod
their spinach cans open

room empty, the leaving
is all that's left
a lifetime laid bare
against four bony walls

even the collapsed
wallpaper has flaked
and been swept off the floor
and all she knows
is that death is a separation
a great walking away

and she imagines
the sound of chalk
sketching out a door
from which to flee.

the heavy

of course there was an enormous hole
smack dab in the center of the house
between the kitchen and the sewing machine
when you chose to slip away

no one was home
(except for the church lady
and you hardly knew her
and so it feels like alone to me)

not one of us was home
to hold some part of you as you left
or hear your spirit release
your last whispered breath

instead, you tossed off your skin
like a jaggy, threadbare blanket
and uncovered this huge hole
smack dab in the middle of our hearts

we all tried to avert our eyes
but that black-hole grabs us anyway
stuffing empty spaces
we did not know were there

an invisible shadow occupies your place
still, silent, weighing a thousand pounds
heavy enough to extract a kettle of tears
or a volume of poems not yet found.

loneliness

shatters the obstinate ego
a sudden thrust to truth
exploding into emptiness
leaving a crevice
hauntingly fathomless

it deafens the silence
possessing the mind
on a snow-dressed
night and penetrates
the blood-beat of life

it hushes a solitary
plane droning distantly
in a dirt smudged sky
pulsating behind
saline-brimmed eyes.

paper dolls

flat faces
bearing faded traces
 like pastels of cotton
 hanging too long on a line
of all those people i love

as if living in places
other than their white sky
crepe paper graves above

an earthbound tapestry
of warp and weave
old family emerges dimly
and woven in dreams

sunset souls with golden wings
paper doll ancestors fold me
like origami offspring.

punctuality. in actuality,

some hosts believe guests will arrive on time
for a change, i arrive at the top of the hour
but i make a joke, *who arrives or leaves on time?*
with the exception of our glorious sun each day

for a change, i arrive at the top of the hour
that hour where time can open, to stand still
in the exceptional, glorious sun each day
and jangles loose, coins in my change pocket

that hour where time can open, to stand still
and my ghost-mother crafts a vanishing act, lifts time
that jangles loose, coins in my change pocket
as lush worlds shrink and wither, fall to winter

my ghost-mother crafts a vanishing act, lifts time
when perennial flowers succumb to October demise
and lush worlds shrink and wither, fall to winter
i smell the earth's eternal clock, the grieving autumn leaves

when perennial flowers succumb to October demise
i hear music, the cycling crunch, crunch of circular time
and smell the earth's eternal clock, the grieving autumn leaves
insatiable wind bawls and wafts closed the coffin lid

i hear music, the cycling crunch, crunch of circular time
a perfect season to die, to take your autumn leave
the insatiable wind bawls and wafts closed the coffin lid
the memory steals me away from home, takes me home

a perfect season to die, to take your autumn leave
today, i smell fresh, damp sod piled above your heart
the memory steals me away from home, takes me home
i feel the wind lash at my cries, sharp and stinging

today, i smell fresh, damp sod piled above your heart
see snow confetti around your rigid earthen bed
feel wind lash at my cries, sharp and stinging
now as then, my tears dampen throat and collar

see snow confetti around your rigid earthen bed
how surprised i am at the strength of my ache
now as then, tears dampen my throaty holler
suddenly, i am twenty-two, a daughter-widow

how surprised i am at the strength of my ache
how did i grow older than your final age?
suddenly, i feel twenty-two, a daughter-widow
i still stand guard by your casket on the twenty-third day

how did i grow older than your final age
can we defy time, travel out to be inside again?
i stand guard by your casket on the twenty-third day
try to imagine beyond my own fleshy dimension

can we defy time, fly out to be inside again
i wonder if you have tried on one of my four sons
try to imagine beyond my own fleshy dimension
i imagine crossing paths with you, a ghost rider

and wonder if you have tried on one of my four sons
giving way to the perfect idea, of no time
i imagine crossing paths with you, a ghost rider
on the prancing wheels of a phantom horseless-carriage

giving way to the perfect idea, of no time
i make a joke, *who arrives or leaves on time?*
not the prancing wheels of a phantom horseless-carriage
yet, some hosts believe guests will arrive on time.

intersection

this feather
resting on my shirt
above my left breast
looks more
like an eyelash
dark brown,
slightly curved
mother-like

i wonder
at what point
did this feathery
lash fall from
the heavens
from my mother
as i walked by
on earth
crossing the orchard
on my way
to the pond
this bright July?

i can feel
her vertical plane
intersecting
my horizontal one
the spiritly
slicing through
the worldly

hi mom.

purple asters are in bloom

and there is that familiar smell
different from spring's icy coldness
this is the dampness of drying warmth

ferns bend and collapse creating a web
that tugs against my bare ankles pushing
through their green pointed tops stabbing
at pillars of sheer light
 late summer's long angled legs
 her ankles collide with mine

and there's the smell of wood smoke
the first of morning fires

i hear the repeating chirp of two birds
their last before migration beckons them off
and we are left mostly with the sound of leaves
crunching in the woods from a distant traveler-

walking to their harvest
through long tapers, silent sunbeams
yet i cannot spy where they are
among the ferns about to turn to fire, orange and red

beyond that, the darkness of hemlocks
calls to me much as winter greets me
with the last squash blossom

this golden warmth holds the coming storms close
 so i cannot see the bright whiteness approach
 or feel the sky land on my face before it melts
now the approaching season's call is all i hear
as i sit under a tree-
 twisted down years ago by the fall of another
 yet growing straight up
 from where its top was buried

this is how i get up when i'm knocked over
i begin to root right where i land-
 straight up, looking forward to skating
 on a black-ice pond.

September Mourning

Election 2000 . . . the Magicians

We work it out, how to ignore the coup d'état
Hard, hot murmurs crumble from parted lips
as we watch foundation bricks soften
to impotent pliable plastics.

It is spring and early morn
we work gently to give way to peace
and the coup d'état
the hinge just oiled on the garden gate.

We watch the magic show, bleary with disbelief
wrestle with illusions flashing from our
charmed boxes, hollow voices echo lies
from our southern state where wolves howl

and in the cool of daybreak
 shed their hungry masks.

 Our masks decode tricks of the magicians' trade
 we wake up to the corps d'état, like in 1913.
 Wildly we roar like bear and waterfall
 drumming on ancient bosom of bluestones.

 Cock crows the sun up and we watch first
 light dance on the crowns of summer trees.
 These thick kings feast on magic and black crude
 and pretend it is soup of split green peas.

 Misted morning lets us see to set sail our course
 bound by light to reveal ourselves as visionaries
 while we pour off the cream of the corps
 into our steaming cups of coffee and tea.

tender november layers

slender stick of sandalwood incense curls its smoky tongue
i see shapes, you and me dancing, leaping off each other
rising and rising from the fire, a woodwind ballet
in november smoke
after

the sugar maple has undressed its bright yellow leaves to bear
autumn's hard edge that freezes them rusty, the color of
weathered nails, crusty as the way i unfold out of bed
and crumble into morning
arising

as witness to the end of familiar freedoms, old standards run
off the plank. feeling the boat rock to and fro, i pitch from
the ledge of timeless, screws stress, threads slip
weighty seasoned wood creaks and wrinkles
bawling injustice bow
to stern.

waxen sphere lights our prayers, sun power born in golden flame
kindling sweet sage cupped in heavy minnesota pipe stone
warm in my hand, polished smooth as sienna skin.
i imagine chisels and crosshatch
files that shaped it slender.
here,

a leaning tree perches a nuthatch, beak and dancing feet moving down
tail jutting up in blue-gray sleekness. rattling the bark, it scurries
over shaggy skin that crunches like a blackish crinkle
where our wetland timbers reach into the space
of sky.

like an old man's beard, these woods are not so thick. not as thick
as younger men's whiskers or young warriors advancing.
not as thick as blood pooling on the hard packed
dirt. not as thick as memories
stirring

under freshly fallen leaves, cloaking fallen soldiers in spring-water
reeds, raising the floor of this swamp one thin layer of skin a year.
tender layers, like precious american parchment
our sublime sons and these twenty pages
of marriage.

September Mourning Tripod

1.	9 1 1	Twin Towers
	It shows natural in- of being trapped *could be you!* To at the top of sky- Peace must be they died for peace. Bomb them with melt from the heat grees. Lose your hands to float give? Incinerated many people jump. prevail. World mar- likes a bully. It sun and complete- the bully? So much their deaths of con- some sat to wait for ed a quarter mile horrific ways, quick. Two thousand souls In airplanes, the calls. So much ter- And doomed people could be made	stinct, the horror Terrorism says *it* be toppling towers scrapers smoking considered. Pray Nobody wins a war. peace that could So hot at 1,000 de- footing. Many held down. Will we for- alive. Off the top, Karmic law will ket hit and nobody must have felt like ly horrid! Who is anguish. Pray for crete and steel. And helicopters strand- high, to die in such They were doomed agree. Tears of us. agony of cell phone ror to be buried. wait. Final calls to lift people . . .
	Can we follow then world war how we will find fare with heat so exploding. Could suicide? But not ant hill, so many	Spirit's teaching, contemplated? Some- peace. Guerilla war- hot. Steel girders there be so much for long. In a giant people are fallen

angels. Can we find families of falling Love thy enemy,	peace? Weep for towers. Not War! up close and pray.

2. sheets

scarlet wet sheets spread thinly on the pavement
floppy human fabric stretched and misshapened.

crimson comforters from commuting early risers
soft blood blankets found under fallen steel girders.

 our collective screaming
 dream is slowly realized.
 we watch it through millions
 of burning squinting eyes.

 ingest it through fingers that
 muzzle gaping mouths.
 heave on hatred's stench
 when giant buildings crouch.

our own salty faces are streaked with ghastly ashen grief
there are people on the sidewalk who look like wet red sheets.

3. before before

i hear it called nine one one emergency day
nameless feelings charge in from other planets
of emotion light years away from so many moons
before for days and days and days

all my mind can ably do is climb the stairs
to its cluttered attic what to see what to see
what to see trying to understand drifting out
i weep in bits and pieces bits and pieces bits and
pieces like how the tower people alighted
on the street soft angel petals

shock waves flow like a river between words
cascades a cry a gasp a sob from the worst
that my eyes saw my eyes saw my eyes saw
i meet with friends and fire we chant we wail we chant
we bring drums and tears we wail we chant we wail
and like flowers wilting near a funeral pyre i lay my
grief at jeff hardy's feet jeff hardy's feet jeff hardy's sweet

i sift through my collections of wisdom sorted in boxes
chambered in my heart labeled by a scrawl of
magic marker naming great spirit on one
another jesus the christ and a tag taped to the old trunk
reads mother earth what to feel what to feel what to feel

one old wooden box keeps my family history
drifting to my grandparents I know they felt like this before
with their wars wars wars
remembering my parents I know they felt like this before
with their wars wars

our children hear us we have felt this way before
with our wars

again like a lost ripple from the black lagoon war
has just fallen out of the sky into a great dark pool of cool cant
the profiteers of war trotting out their politicians of terror

i dust off my heart my heart my heart so better to think
my broom sweeps me back to before
before before

pieces of a thousand years

are we going around and around
the same war for a thousand years
are we finding ourselves or just pieces
fragments of our original nature

today people hunt under steel columns
collecting gold dollars
instead of green leaves

sixty stacked floors try to remember
the sky and luscious trees
bird songs of the woods
endless fresh air to breathe

are we going around and around
for a thousand years knowing
no matter how quickly children serpentine
they fail to navigate the shrapnel of bombs
the rubble of collapsing buildings

mothers pick up the pieces
arms and legs, fingers and feet

are we going around and around
a cruel thousand wars reducing
children to torsos with heads

wherein lies all the memory
of their missing arms and legs.

nourishment

. . . rocking by a window, a mother watches her baby
as he latches onto her milky nourishment
she is rapt by rosy, luscious lips, tiny pudgy
hands that knead her soft warm breast
his perfect song of clamorous gulping
their eyes fasten love together and they know
this moment is the perfect story of compassion.

. . . and kneeling in a jungle, a warrior unfolds a wallet
spilling photos sheathed in plastic
and hosts a sympathetic offering of last communion
to his dying enemy, that he may partake a final
glimpse of his loving family.
in this awkward apology, the lethal soldier, photo holder
attempts to deliver death nourishment.

. . . and spilling from a poem, the questions continue to weep;
does a mother nourish her child to find him armed
and killed in battle
or does a battle nourish the soldier to find compassion
beneath the blood
and does killing turn to madness when an enemy
is found wearing the name human being, brother

> and finally how far have men strayed
> from their mother's nursing arms?

Do not think that I came to send peace upon earth,
I came not to send peace, but the sword.
St. Matthew 10:34

Allow a Slice of Sonnet from My Heart

When you write me, *Christ wields a sword in hand*,
I find deception weighs in what you say.
His blade cuts not the cloth of war for land
Nor stories do His honest words betray.

That, *Christ contrasts His teaching*, is absurd.
This sword cuts clearly two philosophies,
When perfect words of love, as truth are heard
And war-cry's overt claim to Prince of Peace.

As Jesus warns, our houses will divide,
For some shun fear and lead with loving hearts
While some weave words to vest their civic pride
Still boasting, *Christ condones this war, in part!*

 Please know Christ walked His talk, a peaceful lore
 And trust that only love will end all war.

Window Panes

1. Everywhere I see *God Bless America*
 printed under paper flags pulled from newspapers
 and taped to corners of kitchen windows
 or on shiny bumper stickers
 or hand painted on homemade signs
 firmly posted in neighbors' yards
 in our eyes, in our faces
 in our hearts, in our faith-es.

 What would become of America if our precious
 planet fails to succeed? I can only say everywhere please
 God Bless Earth!

 Sincerely,

 a planetary citizen.

2. Early dawn clouds,
 still breathing the dark blue of cold night,
 untwine their long gnarled fingers to reveal
 a bright orange marble I call shooter sunrise.

3. On a three-week-later day
U.S. bombs over Afghanistan began to fall
an anti-war march at Union Square Park sounded
powerful pleas for peace, wired to wrought iron fences
crayoned on cardboard
Long invocations;
 to stop violent retaliation
 to withhold from aggressive action
 to lead with love.

Who will be first *not* to bomb?

4. snow puts an end to routine activity. people
move about deliberately with intent and purpose
trudging with snow-quiet movements.
even deer cease to graze.
not well plowed, the roads are greasy.
frivolous ventures for children and travelers on foot

to the bridge and back on foot, on ice, on snow
a wonderful walk under clouds and evergreen
boughs cloaked in frozen white crystal pillows
fallen from where blue sky once caroused
an infinity of flakes blanket the ground.

 wet walking weather
 snow still spilling south to the river
 windshield wipers wanted
 to clear wire-framed corrections
 wear a cap to catch dripping drops
 draining down spouts into ditches
 dug deep at their mouths.

5. A January train honks its way into my bedroom
through a cracked window
I picture it gliding on a gravel bed curving
above the river at Skinner's Falls.
Listening to the rocking sound,
I almost sway to the sawing of metal wheels on steel rails.

It whispers, *good night ~sleep tight*
 ~good night ~sleep tight ~good night ~sleep tight
as it hums and rolls.

 Three miles
 along the track
 I hear the train horn
 blow again, this time
 on the north side
 of the bend.

6. monkeys atop the onions
brown skins glove them both
perched in a wire basket
where we have tea and toast.

stuffed monkeys play with children
the onions wait for a supper roast
both squeeze in the basket
gifted to the kitchen host.

the onions caged in pewter
the basket about to choke
the monkeys are off the floor
at times, that matters most.

Ballad of Andy Brown

Meet me in the graveyard
facing west from Pleasant Mount
I'll be standing by the graveside
of Sergeant Andy Brown.

Old Glory hangs half mast
at the square in his hometown
where a sign still begs a prayer
for wounded Andy Brown.

He gave his life in old Iraq
his body Pennsylvania bound
this grave the final evidence
of young man Andy Brown.

Meet me at the graveyard
facing west from Pleasant Mount
I'll be weeping by the graveside
of Sergeant Andy Brown.

Passing through Pleasant Mount
where sorrow grips the town
a home just grew more empty
by the loss of good son Brown

Remember friends and neighbors
when your hearts feel broken down
pray for peace in every action
and bless all brave Andy Browns.

Like Alice,

I see everything is not as it seems . . .

>so wake up market men.
>your greed is killing children, their fathers
>and grandfathers and pregnant mamas.
>
>Wake up warrior men
>your need for power is smothering
>the breath of our sons and daughters
>
>Wake up tyrant men
>your desire for kingdoms on earth
>is choking our freedom.
>
>>And at the end of these days of war,
>>where will you wipe the quiet blood
>>off your feet?
>>
>>Will you stop by green meadows
>>beg wild flowers to lick dead souls
>>from your hands as you dangle your
>>arms among their soft petals?
>
>Wake up killing men
>swallow your light, hidden in shadows
>and end this war against our children
>
>This war against our healing hearts
>against hope that we might all watch
>the next blue moon rise.

Black Armband

Lynn E. tears a strip of black fabric, pins it around her upper arm. *For the Constitution*, she explains, as we ready our march to collect the remnants of the parchment, stitch together those checks and balances that crumbled, like shattered stars falling from a dark blue cotton sky, that disintegrate before our very eyes. Draft holes in the fabric, letting in the wind and peeping spies, patriot acts and terrorizing lies from capitol city kingdoms where we arrive to march for our democracy and Iraqi lives.

Fighting for Peace is like Raping for Love

This poem, like the last remaining shadow
of winter's sunset, draws upon a peace march
a pilgrimage of people who gather from every state
offer hope up to a cold January sky, Americans together
knowing truth is the power of the people and great
and glad we are, pitting balloons and songs against bombs.

Speeches, chants, Seeger songs, resisting maniacal bombs
that etched Japanese lives forever in carbon shadow
ghostly silhouettes in flight on mortar walls, death great.
We know this atomic age, yet troops continue to march
and so we continue to march, our voices lift together
peace to all ends, demand the west to east coast states.

We arrive, from New York and its neighbor state,
in Corporate-Kingdom city to demand a stop to U.S. bombs
we believe in the collective consciousness, power together
hearts pulse with conviction, as we face a slinking shadow;
well-laid furrows of fear, a well-plowed media-distraction march
from bank bubbles to hot air blowing through wall street grates

This regime cuts at our wilderness, protected and great
and to the wealthy top-ten, allocates a tax-break state.
White House whitewash is why oh why we have to march . . .
news trailers announce, *The Iraqi War, starring smart-bombs
over Baghdad.* They're lying low, flying in their own shadow.
Our Constitution was written for citizens to live at peace, together.

The U.N. calls this war illegal, despite cant reviews, pieced together
as breaking news, the *Countdown-To-Iraq*, a 30-second-bite of great
decree uttered from a perky dyed do, pancake cleavage in shadow
peeking from navy blue, in front of a neon flag, a star for each state
(whose peoples maintain peace and never want to be first to bomb).
War-for-profit is wanton; thirteen stripes for thirteen peace marches

Protest signs, words shot like arrows from archers, the marchers
at the White House, shouting, *Whose House? Our House!* Together
we beat drums, chant prayers, raise the energy, drop peace bombs
try to strip this combative-corporate oil man down to his great-
grandchild, tell him we are the people who govern these fifty states.
And the banks and corporate war-profiteers are merely shadows

oily, shifting shadows, that make a good day for a boot-strap march.
Going home, crossing state lines, We remember all of us together
ideas, quantumly great; use love energy to *Drop War, Not Bombs*.

the tribe inside

people of all races
on most continents
from most countries
march together
by the 30 million
in hundreds of cities
people of every age
creed, gender
again and again
year after year
bloody war
after bloody war
calling for, *peace now*
in native tongues
marching together
pole to pole
people to people
the peace revolution

we are each
the tribe inside
the world peace tribe.

piped the People of We,

The Emperor has no clothes!
and we all see he has no balls
above the knees, no diplomacy
no guts to threaten us all with peace

we see right through his holy cross
bragging about J. Christ being top boss
jabber-lipping as if Jesus endorses war
then leads his fabricated death chorus

the president likes a regal chew
a bit of old bible, the war parts will do
he swallows whole, sets his puss to pout
before he drawls at the camera
 folks, i, i, i, know for sure
 there's a war to be won
 and there's no other way out
 for u-u-us greedy whores
the spin doctor hisses above his engines of wars

no clothes indeed, yet we can barely see
this member is as invisible as his foreign policy
a cold, hard clinker stuck in the throat of democracy

still, we spring forth and gather our song
 my country 'tis of thee
 sweet land of liberty
we rise
like the phoenix
the People of We.

A Litany of Lies a Listing

Twisted their tongues, the magicians are singing
lies, that crash planes into buildings, are ringing
lies, that craft wars for profit, are stinging
so many lies the toilet is brimming
let us list the lies from the beginning

The election lies, the ostensible winning
when Kat Harris cheats and stands up for sinning
in the midst of the rabid republican dinning
the Supreme Court spins a four to five vote inning
to shackle the recount in Florida from working
in the year two thousand, Cheney is smirking
and George and Jeb and Katherine are grinning

Next, the People of We, need investigate
the awful exploding twin towers-gate
with it's high explosive, pulverized plume
—proof of a perfect detonation-gate
seems a vacuum collapsed the buildings at a faster rate
than would be from just gravity, height and weight

and later, when Bush emerges from hiding away
his odious comfort to the country is to say
keep working, go shopping, you find a way
and Cheney, Rice, Rummy and Powell

begin their lying in earnest and out loud
they chant the fear, they rant and howl
they veil the truth of the house of Saud
where fly fifteen hijackers on the prowl
then Saudi planes only, in the sky are allowed?

Now wars have been on, for years without pause
and hundreds of thousands of civilians are lost
44 hundred soldiers are dead, and yet, *no WMDs boss*
even more are maimed (abiding whose laws?)
What price does this corporate-kingdom cost?

These gangsters play at war, as easy as dice
they're a curse worse than rodents (no offense to mice)
ten billion a month is the current price
(that kind' a dough could buy the whole world rice)

And Bush and Cheney and Rummy and Rice
campaign on their lies, use power as their vice
buy the media ingredient to flavor each slice
then order the wars and pretend to make nice
while stalking dissent with their spying device

Our congress fails us, in representation
they are rich devotees to rapacious corporations
our laws are for sale, at We People's exclusion
to tax the wealthy seems a fair conclusion

These dogs are the worst, there is no question
so many lies, we need another section
there's forthright fraud of Earth's protection
they slay our planet with their greed and pollution

While men in suits tool voting machine selections
keeping Diebold's promise to the re-election
no recount of votes in the Ohio election
no paper trails, no honest inspection

Their lies unravel our constitution
and authorize torture as a new solution
water-boarding is like American soul-pollution
and these lies kill prisoners, their lies kill troops
these lies are crafted by unholy dupes
We People are fraught and plead absolution

With more lies presenting, we ask more questions
about Hurricane Katrina, while taking a vakkkation
the neglect of equality in our struggling nation
and deceit about kicking fossil-fuel addiction

To speak in lies seems their only conviction
bailing out banks with no 'trickle-up' solution
that's war on democracy and that's non-fiction
and quite offensive to Earth's Peace Revolution

So we challenge their lies and hearts of ice
we call for Impeachment, we call for it thrice
charges of war-crimes is the world's advice
throw them in jail, throw them in twice
although federal prison seems much too nice
for Cheney-Bush-Rummy, Powell and Rice
a stay at Camp Gitmo or Abu Grieb might suffice.

barbeque at Powell Library

i find the library is an odd place
to barbeque American-citizen meat
a bull with health conditions, no less
but his parents are off the boat from Iran

so the campus security invites the UCPD
to macho-man the grill (umm-m)
whip up a torturous electric sauce
a new tasty taser flavor basted on
by the (invitation-only) rods of LAPD

you know, they like their dark meat cuffed
entirely restrained and subdued
when they click-clack clean the bones
ZAP!, a knock-you-off-your-feet blast

i hear their jolts are real big
rods that massage in mega volts
nice current piece, officer hunk-o-bully

then the LAPD invites the aroused library
community to eat some barbeque too
alas, no one wants to taste the flavor taser

and no one asks the American
born Iranian what he wants to eat
cops today seem eager to force feed
taser, you see.

to the fracking gas frackers:

you tread where angels
keep our waters safe
you tread where people
dream the lives they live

you tread on home now
lay down your drills somehow

you tread where earth
carves out its flow of Delaware
you tread where only air
only air is down there

you tread on home now
lay down your drills somehow

you tread where joy
vibrates everywhere
you tread where earth's
guardian angels laugh

you tread where shale
coughs up *empty* to greed
tread away from this river
away from its hills and dales

you tread on home now
may you have god-speed

hosting *the 21st century,*

walter cronkite
never reported

on the *new world order*
and their end run
from the year sociopathic
to their kingdom come

i think they'll be all but done
by the end of 2012
after the gulf of mexico oil spill
their spin will be spun

and our minds are either going to shake
awake or succumb to these snakes
that behave like the offspring of cain

listen to patti smith's song sung
louder than before, longer
than our tender blackened shores

people have the power
she was grooming us boys and girls
late in the 20th century to bloom now
with our own family flowers, because
it's 21st century peace-out or bust, world

the new revolution is our mind thought
joyful thoughts to save human kind
 are we kind humans? or
 just kind of human? or
 humans of some kind?

the new world order
needs to order some scruples
because we all see the oil spills, mining deaths
the poisonous gas fracking drills
we all know of the collateral kills
in trade for war contractors' profits

there is corruption in the big house
on the hill, our representatives
selling-out the people's will

so a world-wide *will* of people's peace
collected by the internet, took to the streets
30 million marching feet, in february 2003
 this is when we first meet
 the second time is occupy wall street

releasing energy via mind-tech
(the media barely speeched it)

 right before the *new world order*
 began their 21st century killing spree

will anyone
be free

until our minds alone
become the next internet
wireless

bumpers

the bumper-sticker on my car
that says *create peace,* is there first
to remind me, then my fellow travelers
all on the same long road, to wake up
against all odds, to wake up

against all corporate enemies
who sponsor the wars
and commercial radio and tv
corporate enemies who
psychologically own each mind
that volunteers to buckle-up
to their various screens

unplug your tv's, i want to scream
bump into yourself
your friends in the flesh
the sky and forests and seas
how peaceful we all want earth to be.

radioactive rain

for the people in the Northern Hemisphere

i imagine the dream just to survive
i am living in a bubble inside a bubble

the latter is some other's dream

in this way i take cover in that round place
where a red sun tries to snow and rain on me

red sun's flaming tongue laps at the salty sea

repeatedly i fall to my knees, though i try to stand
i call with a voice that sounds nothing like me

now my iridescent sphere floats by crusaded deserts
their billowing smoke shape-shifts in the wind

mixes all the blood into pools of cooling water
i think, this is how the money is spent

it's not my blood but i pay a tax to slit it free

i read about the day the oil begins to rain
it mostly comes down like bullets and artillery

the dragon's breath strums the devil's harp

but i feel safe in my bubble inside a bubble
and i think this is why blood smells like metal.

Crows Into Night

i see

the business card immediately

dropped on the oil-stained
concrete, a coffin-shaped flyer
face down by my feet, bright
fresh white, laying where car
tracks leave their treads
under cover, at night
in the back mountains of pa.

> like a cracked shell in an iron skillet
> unwanted debris against the black.

i reach down for the 80 pound
Bristol stock calling card
pick it up, read the hard-boiled copy

> and yellow-yolk belly-balls!
> *grand master* crows the card's pen.

i see a spy of a plan to try to inflame
by a card-drop, from a pocket
from a cock in the k.k. klan
post office address inked in

i feel certain the card was left
as a threat to the clerk who dared
to come to work in darker skin.

> this egg's a neighbor
> i think then.

Neighbors' Talk

Wordlessly we agree to keep each other safe sharing our borders
and common roads winding and waterways of river wide
under starry night sky where we play and work and recall each other
as small-town freedom keepers,

> *It's the brutal noise of ATVs revving on hard top, dodging my car
> and driven by the brazen pluck of a twelve-year old atop!*

knowing a breath of wind in the pines cannot bawl loud enough
to rival the garish roar that thrills a four-wheel rider.

> *It's the tractor trailer trucks on the narrow river road
> rattling my windows as they barrel down on the speed zone!*

Quiet too, we warmly commune like salamanders
lying on sunny red-shale rock, languid and tranquil
as country neighbors can be,

> *It's the blue glow of a soda machine, awake, crowding starlight
> in a one-horse town, after a 100 mile escape of white city nights!*

aware that the moon shimmering off the scales of fish jumping
cannot flash light enough to market a midnight can of soda,

> *It is September mornings' sleep abruptly completed by chainsaw
> vigor buzzing through tiny squares in my window screens!*

at other times, we scurry by like squirrels rustling crisp leaves
scampering to our own beat, noisy as city folk
turning on Monday morning.

Tangerine Gates in Central Park

One neighbor tells me, *I felt nothing. It was too crowded for me.*
I laugh. *I felt thrilled by it*, I tell him.

Thinking of Christos' tangerine gates
weaving the warp of bare winter trees
still makes me feel giddy with joy
six days after I spent an afternoon wandering
through miles of glossy sunset door jams
drapery dropping from the top, glistening fabric
orange as Jeanne-Claude's hair in February.

I am surprised by this man's feelings.
He sounds disappointed, even annoyed.
I explain, *The throngs of people
are part of the art.*

The gates invite us and unite us
to become currents of flowing people,
as a body of water or even blood.
We add color and sound under serpentine ribs.
Everyone finds a way to touch the curtains.

I am laughing again, *The sun plays with them,*
the wind constantly changes them,
even east park's red-tail hawk must navigate.
Everything attending participates.

Christos' golden river in Central Park
his name whispering from every lip
as he drives by smiling with gratitude.
His gift of undulating golden gates received.

I feel lifted by the billowing fabric,
as if my feet were pulled off black asphalt water
by flowing saffron sails flying up and up . . .

The man, an artist in his own right, relinquishes, *I*
should go back
and give it another chance.

I answer, *I'm taking the train in tomorrow,*
to see the gates in the snow

the brown bird

chirps overhead and out of sight
behind the blue box-store sign

spilling a leaf
from its neon nest that flickers
a beacon to the migrating poor
and mesmerized consumers

spilling a twig
to an asphalt lid on the forest
floor, presently out of sight
behind the blue box-store sign

here is my home
chirps the red-breasted robin
free from the forks of branches
free of a tree's leafy shelter

a plastic-wrapped sign
metal skeleton and obelisk
coursing with flicker

here is my home
tweet-tweet, twitter-twitter.

the drink

a man walks into a bar a woman walks into a bar

 anyone of us can see
 even be each of them

 scuffle of shoes
 dim lit entries

the man walks up
slams his dream down hard
down his throat
even the drain

 the woman walks up
 tosses her slinky heart
 even her hair
 like a fringe coin purse

 on a polished
 cherry bar

he sits tushy-cush
on round red leather
with a curved tear

 crescent moon occupies
 bloody mary chair

 she leans in
 orders glass spectacles
 her distance out of focus
 even blind as she looks at

 the bartender, smiles
 empties a bottle
 lays down a marker

the man drinks the drink fast
his sadness hijacked
before the next round

 the woman no more
 wants to grieve, for her
 broken cup of mother-jesus
than the man for
his tumbler of vodka-baby

or missing a ride on someone else's dream

 all agree on the rip
 in the red leather stool.

oh brother,

first, he careers in drinking, folds up
like a sofa bed, springless, in the autumn lane
soupy clouds wash his whole flavor out
spill him to neighboring bars for the weakness
a taste that devours him beyond control
more than his own long draw across ice
clinking cold on his throat like the word
nevermore

i met his disengaged heart today, outside
and sober. later it made me remember
something he told me once, a reprimand
over wine at the end of dinner, saying
you are not an animal, people are not animals
shocked to hear the news, i checked my cranial
science files and replied, *i am a mammal*
forevermore

he never used the term *manifest destiny*
or noticed the re-scramble, *tiny-man-dies fest*
how ironic is that view of manifest destinies
in the universal picture, the world full
of confined thinkers, their re-scrambled
motto, *sin safely tit men*

> such is their perverted prayer
> for man infesting destiny
> engineering the wrath of barren seeds

> the real journey is to sustain community
> and share like when, *Fin Tide sent yams.*

glass breaks, fire is slow

plastic is oil, farms are factories, food is modified
corporate is hedging in on the organic action
this seems like all my country wants to do with its food

which, it appears, we never stop thinking about either
the gathering, the gutting, the grub, the groceries
we are a people that never stop packing food
into cars, onto trains, on sky-planes, to work

our drinks carried in portable, plastic bottles
(spill-proof) synthetic thermoses, to-go mugs
with lids and sippy-holes in the cup roof

our solid snacks come in mylar, vacuum wrapped
zip-locked plastic pouches or containers that burp freshness
to preserve our rations until we can nuke them for lunch

gyrate their molecules at jitterbug speeds
until the victuals are deemed inconsumable
the first twenty minutes following microwave treatment
does anyone wait?

i wonder who first applied the word *nuke* to describe
this popular, daily food preparation and why choose a term
that refers to atomic annihilation? maybe
a word better used to describe genetic modification?
laboratory foodstuff without identification
genetically modified edibles allowed for purchase for our lips
seems the experiment is on, no matter what the rest of us wish
and soon ads from the mad-men will be selling us this dish

coming soon . . . the nano-wave-o,
bakes a potato-pork in 5 seconds
and ready to eat in just 10 hours!
conveniently nano food at 7 a.m.
then set it to cool to the perfect heat
to safely eat, still steaming, for dinner at 5.

when wearing this bonnet, excise chatter

the exercise is to write a sonnet
traditional or modern, no matter
like to lay a little humor on it
just might be quicker to try the latter

and forget iambic-pentameter
ten-beat, second-stress lines, in rhyme couplets
while writing on subjects i find sweeter;
like ripe plums or friends with a small sublet

a quandary solved in just four stanzas
writing thoughtful lexis that give words chime
assures me to know i'm not in Kansas
and Shakespeare, maybe lived in simpler times

 when problems could dissolve in fourteen lines
 with three shots of mead, one goblet of wine.

where *is* summer?

summer is afraid to unpack
this june, afraid to burn with
the heat of sun, the white-
shaded warmth of full moon

always, she tries on her new
wardrobe; skirts and sleeves
trouser leaves and drinks
her way toward september

when the wagon pulls up dry
and she knows she has no
choice but to board and rest
like dead and fallen tree rings

then her blood retreats and summer reclines
a happy sap, on the far edge of next spring.

Blue Jean Sonnet

Each sunset draws its curtains down to shroud
the days we spent, in love with carefree play
when our bare-bottom babies cooed out loud
and chattered to red tractor cutting hay.

So many times we languished watching clouds
like drifting smoke as dreamy as our days.
Later, beneath moon's bright and silver glow
into a native lodge we'd panther prowl.

Where sharing confidence of love and woe
we sang by heart to reach our primal howl
outside, our naked mist bewitched the snow
then rose to touch the silent wings of owl.

 Do, let's find fresh faces, resign old props
 go play in meadows ripe with life's new crops.

beast

Silently, the animal rises on invisible currents
emerald river flows west cutting deep canyon
she keeps astride her restless beast

and steps gingerly through the muddied waters.
In her stable, heat opens like fuchsia flowers
blooming on saddle-leaf cactus and

she wonders how his body would tuck with hers
like warm canyon walls before rocks tumble
like leaves shuddering against this easy rain.

Later she dreams; mustang horses chase the full moon
across a milky darkness, they race their wild beasts
as if tethered to separate stars falling apart.

grace zone

as life nibbles away at our lack of experience
eats at the slack of ignorance
our remembrance freezes

like black ice
even like
when we are lost and try
to hurry backwards to find ourselves

through the dendrite's speeding
serpentine currents
racing in the grace zone

where our gray matter is home
to sculptured memories
that finally arrive to be us.

Crows Into Night

*from Wheatfield with Crows
by Vincent Van Gogh, 1890*

Is it that we are both crazy that I am consumed
by Vincent's wheat field? Tripping over swelling
grooves of paint, I run barefooted down the rutted
farm road that wraps its grassy shoulder around
dancing stalks of golden grain.

Does he hear the crow's quiet whisper? Their muffled
caws call to me from under the soft swirling moon.
I answer back. They lift off and make ready to tell him
that I am here . . . as I was then.

I feel his strength and the paint in his brush plays across
my brow. Mixing damp sweat and warm saliva
from his wet mouth, he touches my naked skin.

>My feet take flight through the tunnel that is his eye
>and together we follow the crows into the rough sky
>turning to blue night.

wingless

he flew off the bridge
a final leap off this stage
to end with his sacred suicide
looming behind the whispers
a quiet option open
while he could still decide
where to put the madness

he flew from a height
after growing tall himself
of winter white sycamores
a blackbird without wings
flying from the torment
of a brave son sacrificed

 like crows into night
 we are all soaring
 to the other side

 to what appears darkness
 until we enter

hands in march

two hands falling. torment taking
leave. they belong to my friend. over
river, hands cast ash on the wind, ashes into
water, dust is his hymn. in late spring i will
think of my organic friend when i first
swim the delaware with him again.

for us time crosses from real to imaginary as spirit charges
forward in another new experience. weightless. we keepers
of time unplug the clock, still the hands, mark death.

divorce. rattles all that feels content, shatters all that is fixed with or
without glue. a gordian knot cut with shaking hands. the pieces
never look the same. even so, a new puzzle gets built.

there is a dream of children reaching out, fingers on keyboards
ambassadors of global internet concord. hands of hope.
contributing editors of goodwill. young soul of america.

our final connection is human accord. something
satisfying. like a billion people touching hands
around the belly of earth. passing bread.

white paper bag

but for the colored yarns on the bottom
the bag is empty.
two precise creases close the top
crisp paper like fine white linen
starched and ironed.

in her other hand she holds
a braided rug that is half finished
like her age.
these collected threads
are not enough to weave her rug
or her stories.

now, the bag is lost. she feels lost.
caught in tumbling currents
thrown off balance capsizing hope.
flailing, she gropes, remembers

she knows how to shoot these rapids
newborns and nursing
mother, wife and working.
disposable everything.

she enters a sacred sanctuary
looks for the white paper bag
cradling strips of earth toned rags.
she yearns to plait her rug
anxious to craft herself a rest
shape her soul some sleep

secretly, she wishes the white paper bag
was full of bakery treats.

Bone

Fingers trace a new chip in the bone china
freshly broken from the rim of their marriage

streaming tracks of well steeped tears
and honest promises broken
much like the view and their wedding pact

hidden truths blow through a bone cold crack in a sapphire
night, spinning their damaged union an orbit apart
her husband fiddles with a gold band loose against his skin

a new ring around Saturn and he watches her stare cloud
to a sepia portrait flat and distant
as if painted on translucent bone white plates.

She imagines her lover's damp breath, a whisper on her skin
like morning dew on dry meadow bones next spring

striking a torch under the kettle she whistles up a whirl of leaves
of constellations of stars and orbs and lovers
a brisk swish of secret that surrounds and churns them.

Slopping a spill from the spout like a splatter of marriage
a last crack of knucklebones on china hearts
before tea-drops splash the saucer.

later she pours herself into her lover's concoction
china cup brimming, honey at the bottom
deep as the marrow of bone.

riding,

in the car, it's her arm that has him distracted
as it rests against his own. neither pulls away
he wants to feel her skin, feel it meld into his
where does his arm end and hers begin?

somewhere in the soft wave of gauzy hair, there
where her heat emerges to skim his silence.
he loves that neither of them moves for a while
notices how easy, to let her skin touch his.

right, is how it feels, his arm next to hers
she feels old-soul comfortable.
have they done this before, in a past
or next life time, laid their skins together?

> whether they part or meet
> her skin feels that deep.

ocean song

like ocean waves
that sing immortal rhythms
our love will always be
and must have always been.

constant as luster moon
that stirs the rising tides
this love we choose to share
shines brightly from our eyes.

gray whisker shadow

how did she come to make love to an old man?
she often wondered what it would be like
still feeling like a teenager
imagining her parents or grandparents
making love

and now she is kissing gray whiskers
in the afternoon breeze, in the shade of trees

his lips brush the white streaks in her hair
she opens to him and wonders
how did he come to make love to an old woman?

And gradually from week to week the character of each tree came out, and it admired itself reflected in the smooth mirror of the lake.
 Henry David Thoreau, Walden

autumn cracks

between summer and fall, cackle and quiver.
even autumn trees admire their own reflections
and enjoy the bright crackle of age on a sliver

in the smooth mirror of a quiet river
where creeping dark waters lap at our patience
between summer and fall. cackle and quiver

glance back to young spring, the morning sun giver
glimpse forward to winter and old connections
and enjoy the bright crackle of age. on a sliver

of spirit, even trees trust the river
to carry their leaves, like a thousand nations
between summer and fall. cackle and quiver

as north wind whips icy shards of shiver
love your strands of silver confection
and enjoy the bright crackle of age on a sliver.

push off from shore, surrender to river
and crack through the rapids with kind affections.
between summer and fall cackle and quiver
and enjoy the bright crackle of age on a sliver.

look up

lay down
beside my ashes
once you place
them in the ground

as you lay
down by my grave
on your backs
circle around

turn your hearts up
to the sky and let
smiles replace
your frowns

give me a chance
to see your faces
this last time
we gather round

look up, look up
for chances are
i'll be that cloud
looking down.

the daughters and the locust root

eighty-odd years makes the light
long enough to grow the old locust,
to make the branches thick, the bark
tenacious, calling up the spring bloom
hanging heavy in weight and scent
fulfilling the air and three daughters.

fragrance of locust breath slips into
the wind and everywhere the women walk
they belong to the blossoms that let go
their tender white petals that tumble

through a warm puff from blue sky
a lost snow-cloud spills white on green
where soft flower bellies curl towards
the june sun to tan brown.

and so it goes year by year
zero to eighty-three in under a minute.
a granddaddy tree with roots deeper
than three daughters can know.

as they ponder the old locust in the shade
under its branches' reach, the daughters
speak of *uproot-ment* and *transplant*
of creating safety through excavation
to improve the view of the future, as if one
could shovel up *safe* and toss it beyond *here*.

did they ask, how full will the flowers bloom
tomorrow, if we dig the root today?
let go, whispers the wind, *be safe now*
let go daughters of the locust tree
allow the root its drink of rain
this winter bloom and summer snowstorm

let go the rough and shaggy bark
the red thick thorns that prick so sharp
let go the locust tree to bend and shift
let birdsong and piano keys
accompany its dancing leaves.

Water Bearer

women drumming

first strike of the drum
calls the women to gather
and sit in circle
according to age
beginning with the elder
 like a drum made of women
 a rim of female vision

and slowly they begin
beating percussion prayers
leather voices
skin upon skin
pounding rhythms
 speak as one heartbeat
 with ancient intention

and they cast their song
high into the night wind
to surround a troubled world
 so round and connected
 like this circle of sisters

from drum to soul to pulsing heart
they bless their sacred vibrations
with shadows of sound
old indigenous echoes
from a chanting primal choir
 still thundering amid
 these worn appalachians
 ho!

sweat lodge

across night meadow, an ancient way carries on
ceremony beckons your own people come home
here, near a low sapling dome, in mist by moonlight
bonfire blazes, baking rocks from day into night

ceremony beckons your own people come home
sealed tight with rugs, tarpaulin, small rocks and big sticks
bonfire blazes, baking rocks orange day into night
sweat lodge in meadow grass at its center, a pit

sealed tight with rugs, tarpaulin, small rocks and big sticks
you shed your dressings, discomforts and best fears
sweat lodge in meadow grass at its center, a pit
by a pond at rest, gleaning a palette of stars

you shed your dressings, discomforts and best fears
through the low east door, we stride like panthers
by a pond at rest, gleaning a palette of stars
and the fire keeper forks out rocks for the pit

through the low east door, you stride like a panther
and sit in circle, in such darkness as in caverns
and the fire keeper forks out rocks for the pit
then sparkles the dark with flower-dust sprinkles

and sit in circle, in such darkness as in caverns
glowing rocks hiss and join drums in the praying
then sparkle the dark with flower-dust sprinkles
and you pass the bucket and ladle and water

glowing rocks hiss and join drums in the praying
as steam stings your skin, you sing to remember
and pass the bucket and ladle and water
then melt upon earth, under tributaries of sweat

as steam stings your skin, you sing to surrender
and sound sharp thunder to waken the sky
we melt upon earth, under tributaries of sweat
be-coming no-time and every-one at one-time

and sound sharp thunder to waken the sky
you call out to ancestors who have walked before
be-coming no-time and every-one at one-time
the ceremony gathers the tribe once more

we call out to ancestors who have walked before
here, near a low sapling dome, in mist by moonlight
the ceremony gathers the tribe once more
across night meadow, an ancient way carries on

Woodstock Nation

for the 20th Woodstock Reunion, w/ Lunar Eclipse, Family

We are a shadow
 on the moon
 a crescent beam
 of darkness

 carving its way
 to complete night

 Woodstock
 Nation
 gathered once more
 feeling the earth
 move beneath our feet.
 We howl from
 our primal hearts
 one body
in the cosmos.

Rainbow Gift

We stood in awe
rain misting our faces
on the porch of our new house
gazing at the rainbow
emerging through the storm.

It began next to the red shed
arcing over the slick road
dropping to touch down
on a nearby wooded slope.
It was so close we could have climbed on it.

It brightened to an intense
luminary of colors
contrasting the wet
and still
bare red-bud trees
amid deep green pines.

The rainbow came to punctuate
the wonder of our new home
confirming spirit traveled through
this gifted journey
as our dreams play out and draw
themselves as miracles circling
like eagles at play
on this mountain top.

strawberry moon

we toast red wine at sunset
to mountains
to marriage to life

while strawberry moon rises
luring us rapt
by early night

we turn on curves of green earth
rolling gently
beneath twilight

ceaseless, constant and pulsing
like Eros still
casting love's might

we hear red dusk and blood speak
while coursing through
fingers entwined

be love, horizon and sky
and know silence
that keeps them wise

walking earth

walk the way of earth
sing a song with each step
walk the path of deer
walk the path of bear
sing a song with every breath

walk through wood
whisper ah-ah-ah song
walk on humble tread
on quiet mats

pine needles as deep
as ancestors are old
hush to silent thread
walk through wood
sing a song with every breath.

celebrate life

to the sun
to the moon
to the stars
chant your tune

beat your drum
say a prayer
dance your feet
and be here

celebrate life.

the golden eagle,

perches like an angel
carries a memory in need of a dream
(though i did not know it then)

makes me turn my car around
a bird this big i have to see

now, standing beneath the command of its presence
unmoving, on the lowest branch
of a grandmother tree

our eyes fix on each other's
in this wild space, absent of time
and traffic and texas

where a whoof of wings is the whisper i hear
followed by a lone crack of ice
on late-winter, neversink reservoir

> like the crack of gunfire in my dream that night
> shot back to texas
> back to a native life
> to a village of thatched huts and bison medicine
>
> then in a flash, (as dreams go)
> shot dead by a g-man's gun
> while feeling fearless and fiercely awake
> moving through death, in this dream

 that flew through my sleep, made me feel empowered for days
and after i wake
the golden eagle stays on for months
in the person of maggie abernathy
(though i did not know it then)

a new friend
with her long rusted hair
feathers tumbling below her straw hat

maggie, like an angel carrying a memory
i did not know i had
a memory, i thought was a dream

now i know
maggie came to lead me to texas
with two babies in tow, a pack on my back

to find an indigenous people's burial mound
and in that same field there stood a solitary
thatched hut the very one from my dream

after ten days questing in the big woods of east texas
i sit at the last sundown in that southern july

watching the clouds form a perfect bison against the sky
and when it vanishes there appears, laying over horizon
a long stretch of a single feather, plain as could be

and i think of the eagle in the grandmother tree
animals, people and sky shape-shifting
to help me see.

watching dreams

night frosted time drips like eyelash icicles
 i dream asleep
 undulating through the same force
 that pulls petals off posies
 melting moments like
 warm candle wax waning
 silky streams inside my dreams

shifting sleep opens like summer sun in september
 i dream awake
 watching wet mirage shimmer on distant road
 like morning's breath on rose of sharon
 enriching as sage advice
 aware as sunrise light
 intuition flows from both sides of my dreams

from Road with Cypress and Star
by Vincent Van Gogh, 1890

dear vincent,

the secret, i remembered the moment i saw your face-
it comes to me as easy as the day you told me yourself
and has remained, but for this poem now, over a hundred years
and a thousand suns, setting on peasants in fields, have passed

and still my heart turns at a first glance of your painting-
i remember our evening walks on the road to town past
the cypress trees, where on hot days, we'd dry in their shade
and on warm evenings we'd lie on their soft under-bed
and tell stories cast by the stars lighting our way.

presently, we probably both use the internet, which has turned
nothing up, about what i know and this makes me grin on the inside.

now is the perfect time to tell your secret—when a crossing memory
shakes loose of its veil—the instant i am handed a color-print of your
painting, *road with cypress and star,* to write an ekphrastic piece
here in the middle of this lifetime's first decade of a new millennium

my memory, jars open, when first, i see your face
pipe-stem gripped between thin green lips, the crook of cypress-nose
your eyes already set in heaven's orbit and i find myself remembering
what i (somehow) know you told me, vincent
that in this painting, there hides one of your final self-portraits.

Water Bearer

Aquarians

 Our Aquarian day was dawning and
 I did not know that Mercury was squaring off with
 Venus or some such mystery on a sunny
 day in mid July in nineteen ninety nine

 the kind of mystery that brings three people
 to the exact spot in the physical realm
 at the exact linear time

 that Great Mystery which can change us in
 an instant, lace our lives together and command us to
 share center stage for just one scene in this
 earthly drama that is our home for one dream . . .

 in the morning of that dawning day Quinton
 was remembering Dustin's death eight years
 before. His younger brother he wished
 to trade places with, feeling certain death
 had taken the wrong son

 in the afternoon my dear Christina came by
 brewing with agitation or could it have been
 premonition? She arrived without her son

 one of those rare visits, so I too
 snuck away from kids and we went
 for hard-pack at Riley's ice cream parlor

 cooling off with frosty licks of maple
 walnut and mint chip, we chatted with old
 friends from Hollywood Center, New York

on our way home, the evening early, Quinton
ran into us, square like Mercury and Venus
our orbits colliding without the comfort of
gravity or time. He calmly stated his name
and birth date before begging for water.

Aquarians crashing in triplicate
minds blown beyond the
boundaries of our ordinary lives
fragments of who we once were
scattered on the pavement
waiting for the water carrier

from that day until this the dream
streams on fluid, full and thick
and time forms its own wings
travels at its own pace

and the Mysterious Knowing rushes through us
a soothing cascade of healing winter water
flowing from late January skies that belong to us.
It is the water bearer pouring from her urn.

Biker

In the darkness of my eyelids
I see the fire lapping up the air,
I see the biker second.

The intense fear that is left in my mind
makes me moan.
I still feel the panic,
the instant understanding of someone on fire
 and just me.
 Just me and my long flimsy skirt.

In the wildness of my mind
my thinking is clear and ordered.
Each hundredth of a second
I hear step by step instructions
> *stop going for help . . .*
> *put the fire out . . .*
> *use your skirt . . .*

The world has fallen away from my knowing it,
silent like the fire
silent like the biker
silent as a summer skirt beating flames that force it to float.

Breaking the silence of my cracked world
someone is shrieking,
repeating the rhythm of all the quiet poundings . . .
> of fabric beating fire
> of heart beating chest
> of aching breath heaving.

Fear is screaming out my thought,
He's on fire!
Over and again
giving thrust to each blow levied at the flames.
Jolted back to the world,
I had forgotten that I am not alone.
My friend runs to me
with a blanket from her car.
One last wrap of his legs
one last leaping flame.

We sit and wait with the burnt, battered biker.
The setting summer sun
and the chirping chorus of birds
confuse the moment,
bathing horror in lovely lyrical songs of serenity.

wake

 your wake up call
 woke me up too

 from my window
 i see you walk by
 now we stand
 side by side

 you uncover your scars
 a smile on your face
 you hug me long

 restore my balance
 standing side by side

 all these tears
 still fresh
 from our heated dance
 when you were born
 into my hands
 side by side

 a trace of flame
 shifts past your eyes
 fire fading

 deep inside, invisible
 as our first breath of life

 we glimpse eternity
 in the fading fire
 wake.

Mountain Home

Cushetunk Falls

We never tire of the murmuring water
the soft rumbling roar of Skinner's Falls
or long days on the rounding shore
all rocks and sand and Delaware River.

Languid in the simple summer sun
we wrap the hours in ripe cherries
as conversations drop on the wind
our laughter stretches out behind us
rides over the tumbling waters.

We stay past the sun setting beyond
the bridge, past dusk until our chatter
stills like birds, so we might hear those who
came before, a very long, long ago.

Their voices seem to sigh over the rocks
rush beneath the eagle's final evening flight
a faint murmur of remembered people
telling of their lives along this sage river.

Their watery call holds us to balance
lifts off unending songs of current
songs of us as nature, wild as Lenne Lenape
steady as the soft whisper of Cushetunk Falls.

river glass

 tributaries upon tributaries stream together
 suggesting strings of melted glass
pulsating, like heat waves
 against a throbbing
 August sundown

 the glass blower crafts the river
 stirring constantly in polished troughs
 against sloping banks
 and earthen eddies

 sky blue spangle and cold currents
 sing to bluestone boulders
 long ago named mermaid
and peace rock

that resemble smooth stone
 Goddess buttons sewn to mountain
 edges flanking brocade borders
 of indiscernible states
 an invisible seam, centered
 above the silver sliver

 glinting mirror acquainted with
 the breath of the glass blower
 rolling like a warm wind
 round bends in rippling river.

feathers full of music

rising from the purple cocoon
of thick hemlocks, green heron
flies over water, over rocks
over chartreuse tips of straw

 they conduct the song of wind
 and river, batons heavy with grain
 full of purpose and movement
 her feathers full of music

 she is what she imagines she is
 electric-flying green heron
 skimming the cool off water
 as the whole orchestra sings.

supper table

great yellow sun sets purple clouds
 on a tablecloth of blue austerity
and tips a southbound crescent moon
 to spill milky stars on darkening drapery

great golden sun blesses every breath, songs
 sung by us and wings and leaves
and the air that hums within the rocks
 inside the river that sings to me.

Mountain Home

Mountain meadows
speak softly
of snowflake lace
and golden rod
stubbly grass
and thistles
lying low in the sod.

Summit fogs
speak softly
of darkened bark
and wispy hemlocks
draped in dust
and green moss
snuggling great damp rocks.

Evening breezes
speak softly
of cricket wings
and caressing leaves
waltzing wind
and tree frogs trilling
their summer reprieve.

early

she wakes at dawn hearing
canada geese honking in flight
through the hazy morning mist
rising slower than smoke
over the lake

she listens to the quieting
night crickets harmonize
with distant church chimes
a single woodpecker
hammers in syncopation

two fishers stand ashore
motionless and silent
but for the plunk of their lines
that ripple the water
and warp the mirrored trees

it's early and the earth
still hums its damp lullaby
her two companions sleep
one a loving friend
the other a friendly lover

she tucks back into a red
goose-down bag
eye to eye with dew drops
dangling like pearls
on a delicate wrist of grass.

sunrise sand

peering out the somber entrance
to my oval cave, smoked gray
from the service of night fires
where i have just slept

a breeze glances across my face
dune grasses, the color of september
ponds, resemble obtuse canes of green
sea glass, a bent parade of paupers
stooped from being windswept

my first prayers await feathery flight
on tips of ripened seeds, i rest
as i wake, a cool aura radiates
from purple cradle of shaded rock
a bone-chill crinkle penetrates

my legs reach out for heat
tamping a canvas on the ground
my toes trace a fresh dream
sketching whimsy in the morning
hush of magenta sand.

eagle speak

eagle come back
eagle come back
soaring low above river flats

eagle fly home
eagle fly home
clutching delaware fish and bone

high pitched ee-eee-ee
high pitched ee-eee-ee
eagle's voice echoes through trees

hear eagle speak to hawk
swoop down to chase hawk
sweeping over valley waters
over heads of shoreline walkers

but for hawk's call
but for eagle's call
people might not know eagle at all.

the hot lazy

on this day the river is so warm and low
we hang out in the channel, where the current
brings down the freshest water, just to feel the river
colder than our skin and we can float there
like no other time, barely drifting downstream
the river is this slow and our gang is swimming together
and we all turn belly up, falling into our mothers' womb
trying to stay awake floating on our backs, in the warm easy

it is so quiet and we use all our lethargic energy
just to feel the separation of our bodies and the river
out under the 100 degree heat, the sun hotter
than bluestone frying our feet, we agree
we are the water, we are floating in the poem
and this is all we can do today, swim the river
cruise its shores, startle frogs, watch oriole chase
a snoopy crow from her nest

now we swim upon a green heron, on a rock off shore
neck crooked in suspicion of our approach, up close—not too tall
it decides to fly over our bobbing heads, low-angled sun rays
glinting off the bright jade lift of wings and tail and finds perch
in a nearby tree above the river and turns to watch us
this is the kind day where *lazy* is the best feeling of all.

green heron hunt

those fish don't stand a chance
in Canada's thick wilderness

nor do i-
but for trying my whistle
a sharp, high-low, double-note
wh~itt-wh~oo.

i make the call in rhythm
(like breathing song)
every few seconds
like a singing bird-

flightless but well traveled
fleshy legged, spongy feet
and car wheels on dirt
into deep canada-
to this green heron

a feathered zeppelin
relaxing its yellow beak from
the sapling-stance it struck
upon my entrance
 arriving suddenly from the thicket
 at the mouth of an avian creek-cafe

tweezing fish or frog
it is clear i can stay
on condition i serenade
wh~itt-wh~oo
as i watch this gullible
wader hunt
in the shallows
where long yellow legs and beak
stalk meal morsels ten feet
from where i keep calling
wh~itt-wh~oo

it picks from a north woods
water menu; four courses
slender slices of shimmer
with stealth on the side

wh~itt-wh~oo
is my chorus as this creature
(a fool for a whistle)
quickly flicks and tilts
its head skyward-

flips the pinched
flinching prey
parallel in its beak
and gulps.

inside hemlocks walking

for my four sons

tranquil

soggy purple sky
heartbeat is the only song
coal black bark hushing.

tempest

flat leaf needle dance
windswept branches swaying long
storm's sage voice rushing.

ice-storm taps

of all wide range of winter's gift
of all north country's whitest beauty
an ice-storm freeze stills us to shift

this downpour sleet-storm, gray day drift
this unexpected, day-off booty
of all wide range of winter's gift

cold season's gales, blue clouds are swift
clink-tinkling ice clicks, trees bend mutely
an ice-storm freeze stills us to shift

and charms deep dreams, as warm hearts lift
to watch the birds we feed with duty
of all wide range of winter's gift

boot-toes, snow-scoop, sleet-spheres sift
inside, fireside, cup of hot tea
an ice storm freeze stills us to shift

strong, thriving winter makes one persist
to survive, to watch, to grow rooty
of all wide range of winter's gift
an ice storm freeze stills us, shh-h, shift.

Luna-tic . . . I love that you skated through the lunar eclipse!
~Rosie Starr

Ice Flight

Donning leather lace-ups
with dull steel blades
I travel on winged speed
into my escapade.

Skating over frozen grass
protruding through the ice
around ancient statues
without any life.

I become great blue heron
circling once, twice, thrice
around gnarled stumps
in a decaying paradise.

evening drapes

the sunset casts its gilded light
on westward slopes draped linen white
and diapers clouds in coral hue
and mellow greens of honeydew.

beyond black mountain's crest ignites
the icy winter's steel twilight
it bids the sun its final peace
and fades the cloudy golden fleece.

www.ingramcontent.com/pod-product-compliance
Lightning Source LLC
Chambersburg PA
CBHW030750180526
45163CB00003B/967